UNICORN

Published in 2021 by
Unicorn, an imprint of Unicorn Publishing Group
5 Newburgh Street
London
W1F 7RG
www.unicornpublishing.org

Text Copyright © 2021 Adam Kimberley
Designed by Adam Kimberley

ISBN 978-1-913491-71-0

10 9 8 7 6 5 4 3 2 1

BEER STAINED PULP

ADAM KIMBERLEY

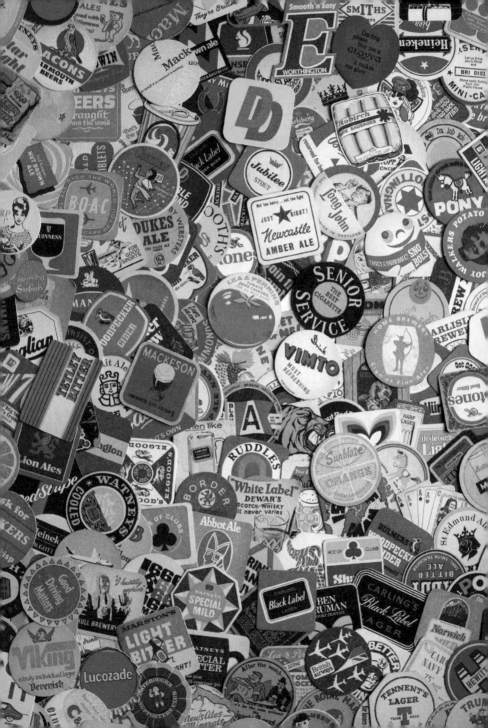

INTRODUCTION

In 2018, I created an Instagram account showcasing my collection of 'nicely designed beer mats from the past'. The idea was to post a new beer mat every day in the hope that they would not only be a source of inspiration for fellow designers, but also as a source of nostalgia to make people reminisce of nights down the pub (little was I to know how prescient and poignant that would become during the COVID lockdowns in 2021).

I began collecting beer mats when I was still fairly young, I remember my sister gave me a Kimberley Ales beer mat and this was probably the catalyst. I pinned it onto my wall and a new hobby was born, before long it was joined by another and then another and soon the wall began to disappear. As I got older and began to frequent the pubs myself, it started to become something of an obsession. I found myself collecting more and more and would often wake up in the morning after a night out with my pockets stuffed full of beer mats! However it wasn't until I went to college to study graphic design and illustration that I realised what a great source of creative inspiration they were.

Beer mats can often have beautiful examples of typography and illustration but essentially they are small advertising spaces and therefore good graphic design is imperative for an effective beer mat. For many these little cardboard tiles also provide a massive nostalgia hit, displaying weird and wonderful advertising campaigns from yesteryear whilst at the same time subconsciously illustrating the development of British culture.

The name 'Beer Stained Pulp' is a reference to the traditional wood pulp material that beer mats were made from. It also alludes to the fact that most of my collection is quite literally, beer stained. I should also point out at this stage that *Beer Stained Pulp* is in no way a definitive or complete collection of beer mats (there are collectors [tegestologists*] out there who have every release from every brewery - commitment!).

This collection is a curation from my own personal collection of those that I consider to be the more fun, unusual, iconic and above all British beer mats, that I have come across over the years. This book has been written to enable you to appreciate these little 'masterpieces' for what they truly are and if it succeeds in that then it will not have been in vain.

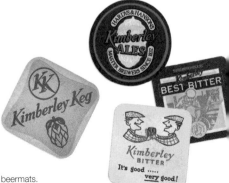

*Tegestology is a term used to define the practice of collecting beermats.

BEERS AND BREWERIES

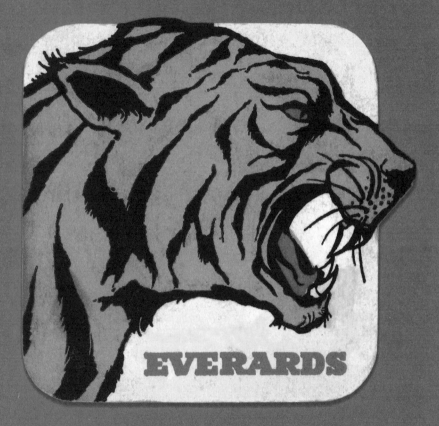

Everards Brewery 1971

Dutton's Ales 1962 • Hammonds Brewery 1960
Watneys Red Barrel 1966 • Worthington Nut Brown Ale 1967

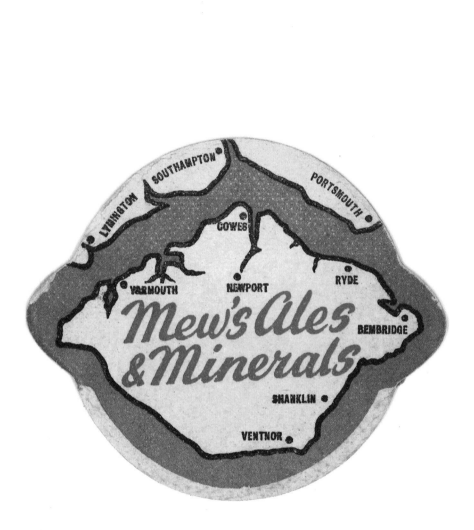

Mew's Ales and Minerals 1956

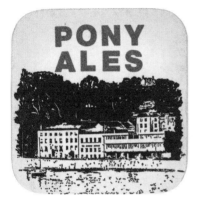

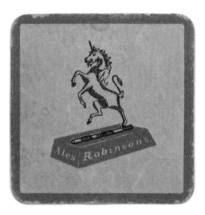

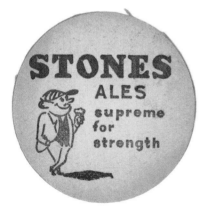

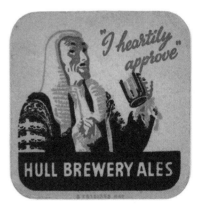

Pony Ales 1977 • Robinson's Ales 1964
Stones Ales 1960 • Hull Brewery Ales 1957

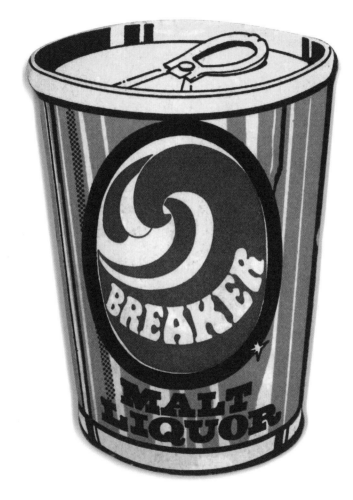

Breaker Malt Liquor 1976

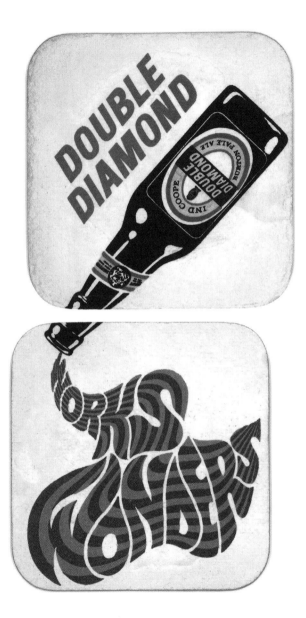

Ind Coope Double Diamond *front and back* 1966

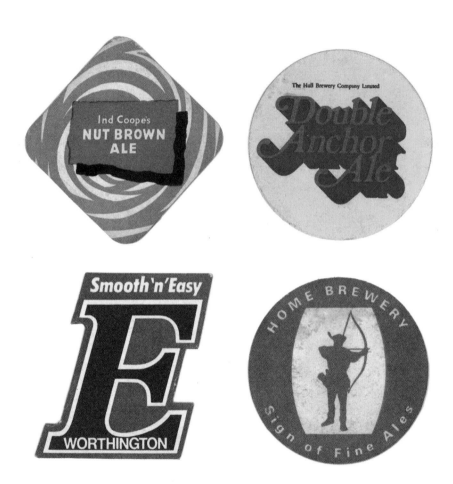

Ind Coope's Nut Brown Ale 1957 • Hull Brewery Double Anchor Ale 1971
Worthington E 1973 • Home Brewery Ales 1970

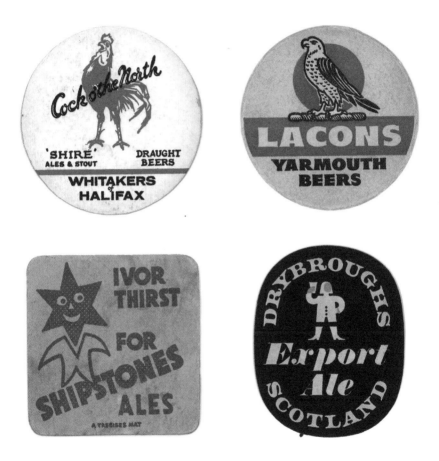

Whitakers of Halifax Brewery Cock o' The North 1968 • Lacons Beers 1962
Shipstones Pale Ale 1954 • Drybroughs Export Ale 1967

TAVERN
KEG BITTER

BREWED BY COURAGE

ery Tavern Keg Bitter 1965

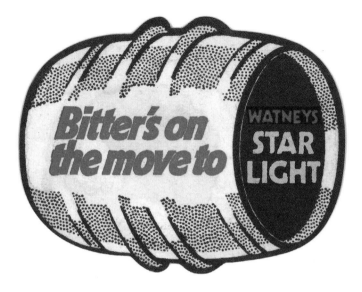

Watneys Star Light 1970 • Tetley Bitter 1987

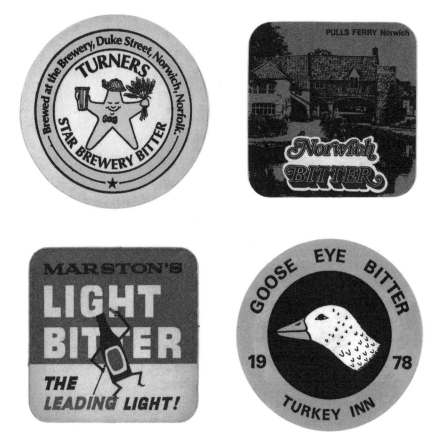

Turners Star Brewery Bitter 1981 • Norwich Bitter 1975
Marston's Light Bitter 1964 • Goose Eye Bitter 1978

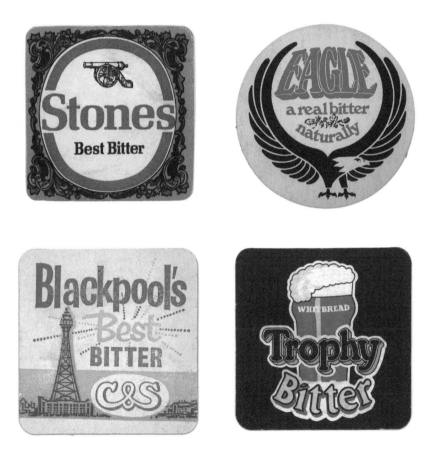

Stones Best Bitter 1977 • Charles Wells Eagle Bitter 1975
C&S Blackpool's Best Bitter 1963 • Whitbread Trophy Bitter 1977

Join the Great CIDER Revival

Bulmers Cider 1972

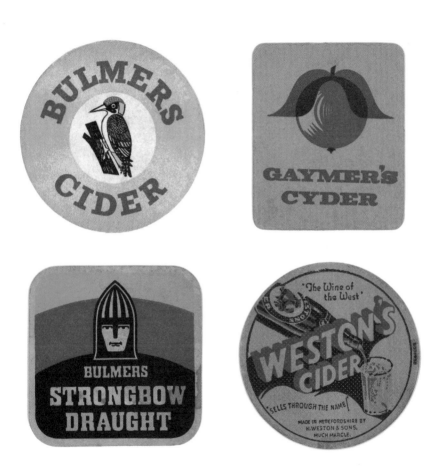

Bulmers Cider 1959 • Gaymer's Cider 1960
Bulmers Strongbow Draught 1977 • Weston's Cider 1950

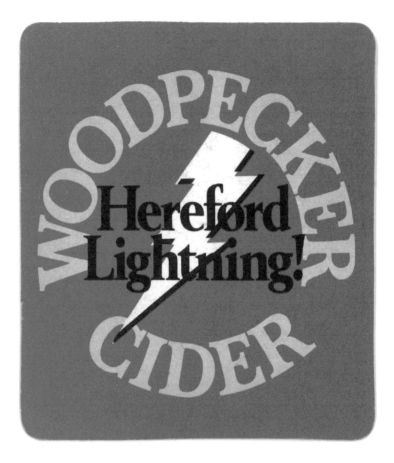

Woodpecker Hereford Lightning Cider 1979

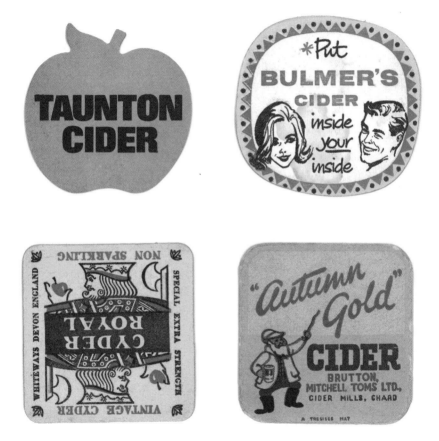

Taunton Autumn Gold Cider 1969 • Bulmer's Cider 1962
Whiteways Royal Cyder 1964 • Brutton, Mitchell Toms Ltd Autumn Gold Cider 1958

Arctic Lite 1978

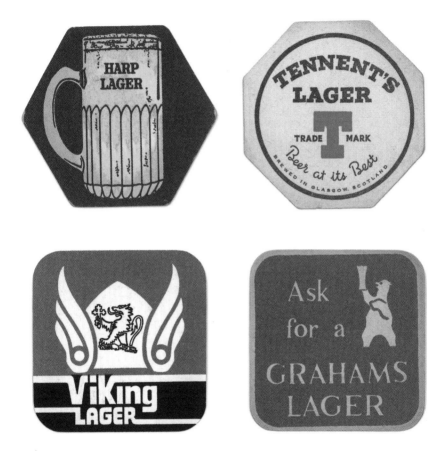

Harp Lager 1974 • Tennents's Lager 1956
Devenish Viking Lager 1973 • Grahams Lager 1955

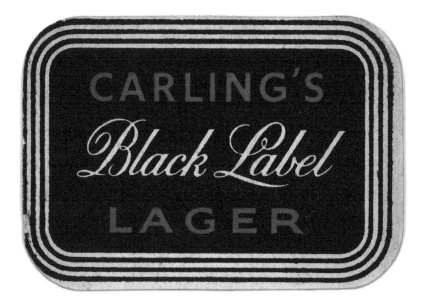

Carling's Black Label Lager 1959

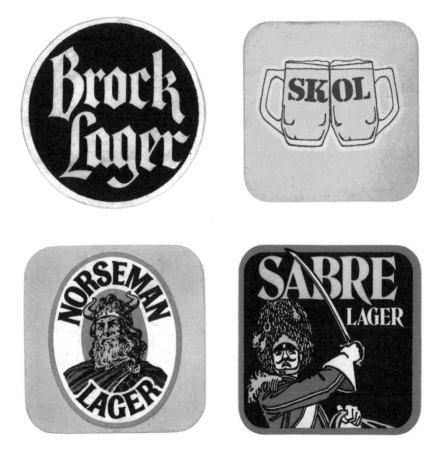

Brock Lager 1961 • Skol Lager 1979
Vaux Norseman Lager 1973 • Sabre Lager 1975

Cameron's Icegold Lager 1972

Polar Lager 1972

Help to Prevent Crime Dial 999

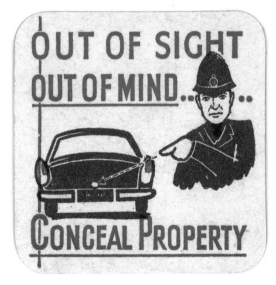

Somerset Constabulary *front and back*

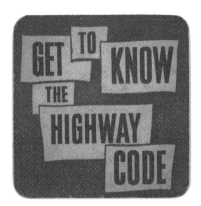

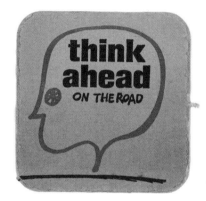

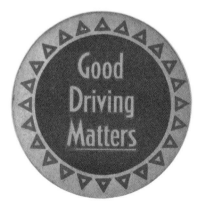

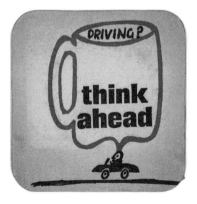

Highway Code • Think Ahead
Good Driving Matters • Think Ahead

Stop Accidents • Mr Featherwate

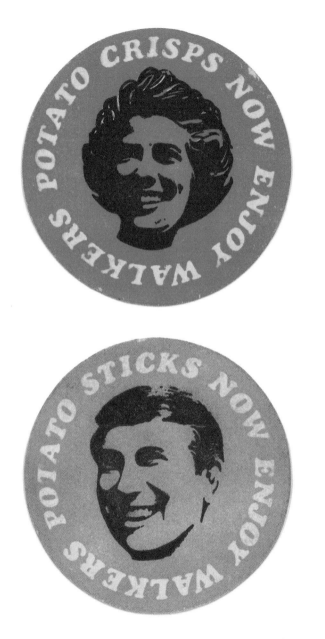

Walkers Potato Sticks and Crisps *front and back*

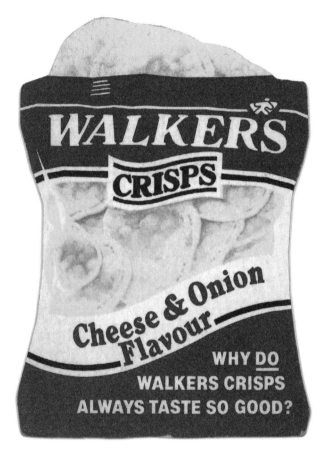

Walkers Crisps Cheese & Onion

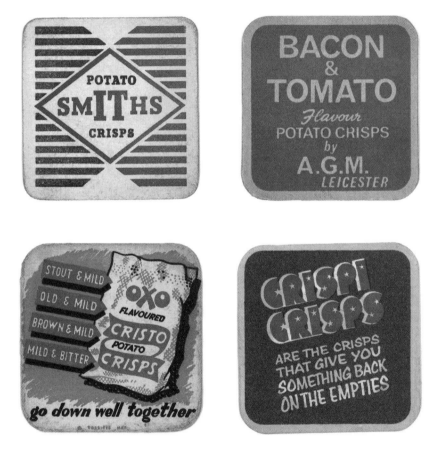

Smiths Potato Crisps • A.G.M. Leicester Crisps
Oxo Cristo Crisps • Crispi Crisps

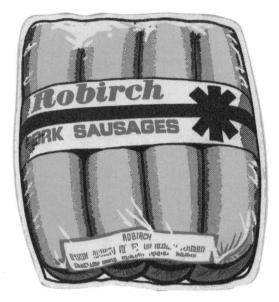

Robirch Pork Sausages • Steakwich

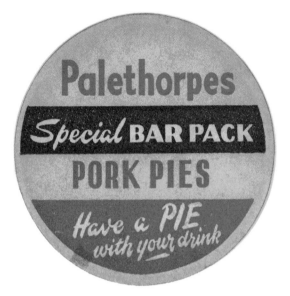

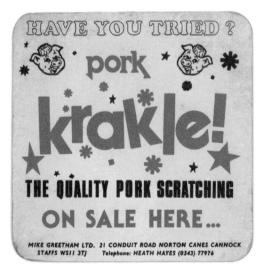

Palethorpes Pork Pies 1955 • Mike Greetham Ltd Pork Scratching

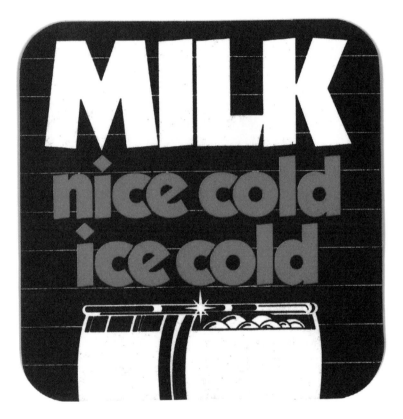

Milk Nice Cold Ice Cold

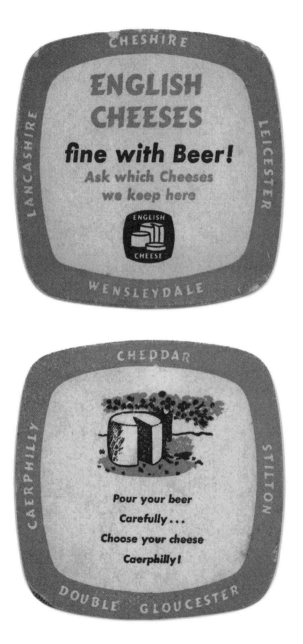

English Cheeses *front and back*

SOFT DRINKS

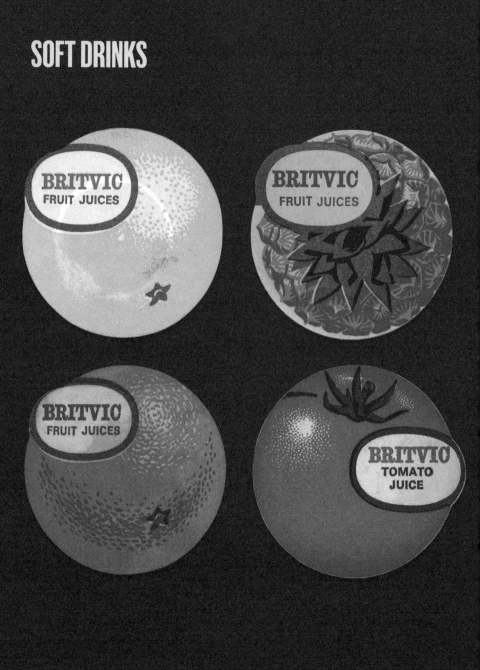

Britvic Fruit Juices c.1970s

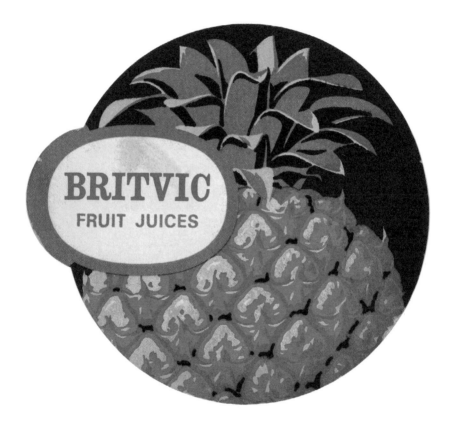

Britvic Fruit Juices c.1970s

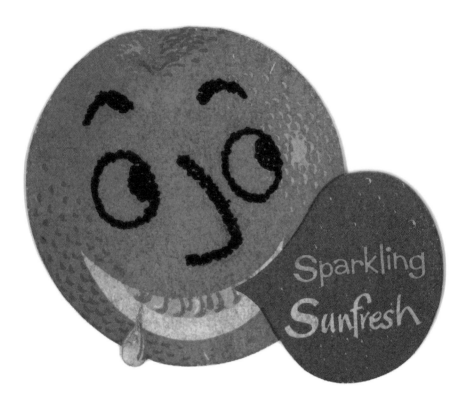

Sparkling Sunfresh

Sunfresh Soft Drinks

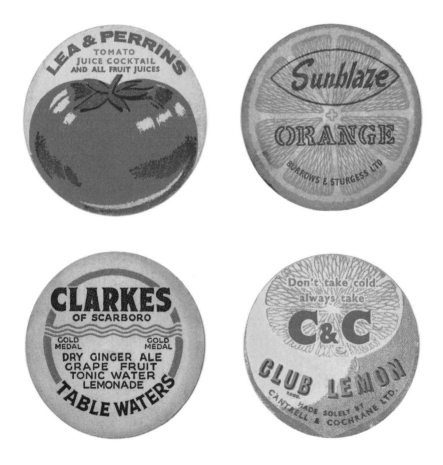

Lea & Perrins • Burrows & Sturgess Sunblaze
Clarkes Table Water • Cantrell & Cochrane Ltd Club Lemon

Dayla Tonic Water • 7UP
North & Randall Hubbly Bubbly Cola • Chandy Shandy

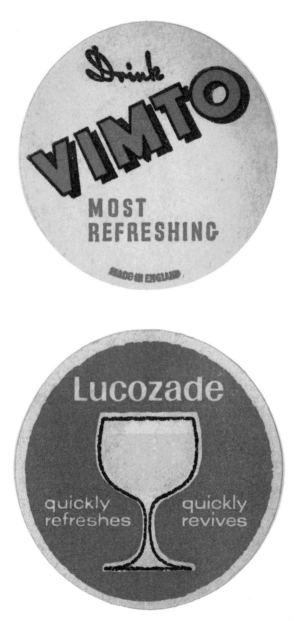

Vimto • Lucozade

SPIRITS & COCKTAILS

Amber Sin Rum

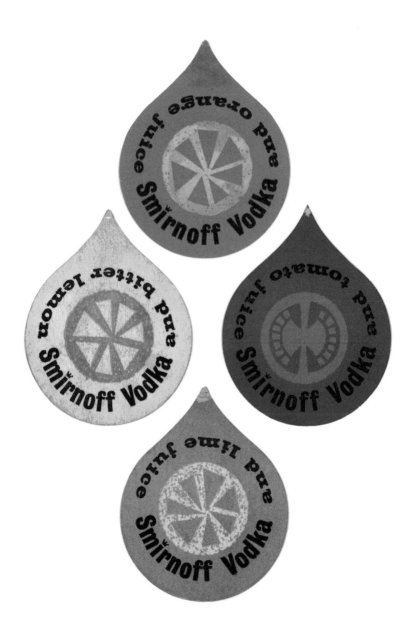

Smirnoff Vodka Cocktails c.1960s

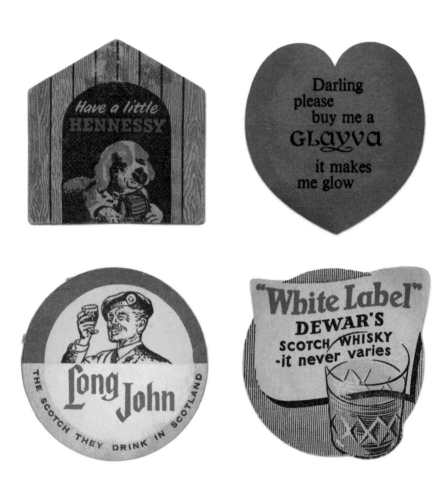

Hennessy • Glayva
Long John Scotch • Dewar's White Label Whisky

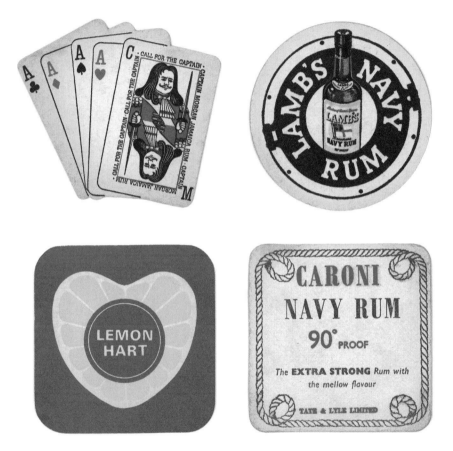

Captain Morgan • Lamb's Navy Rum
Lemon Hart • Caroni Navy Rum

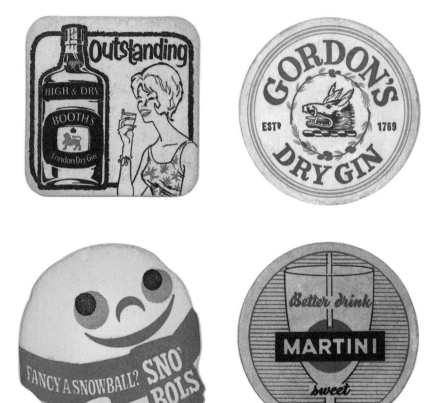

Booths Gin • Gordon's Dry Gin
Sno' Bols Snowball • Martini

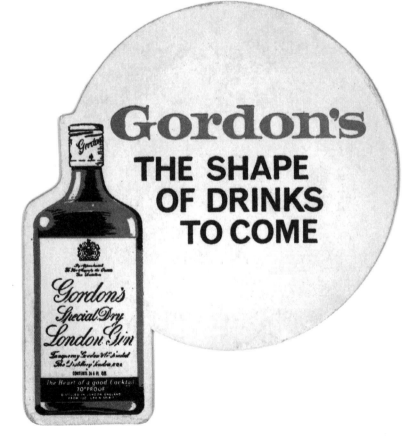

Gordon's Gin

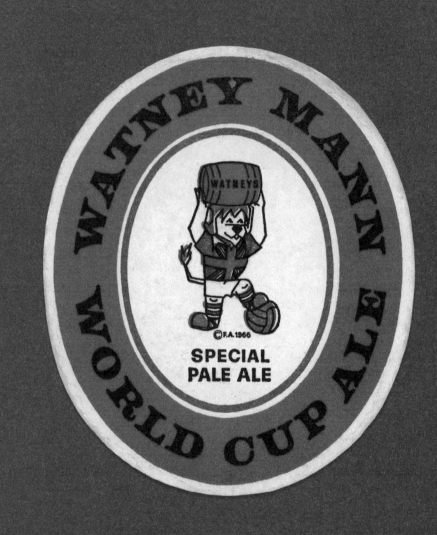

Watney Mann World Cup Ale 1966

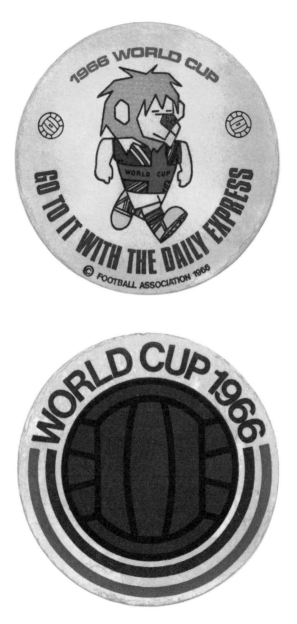

The Daily Express 1966 • Greenall Whitley World Cup 1966

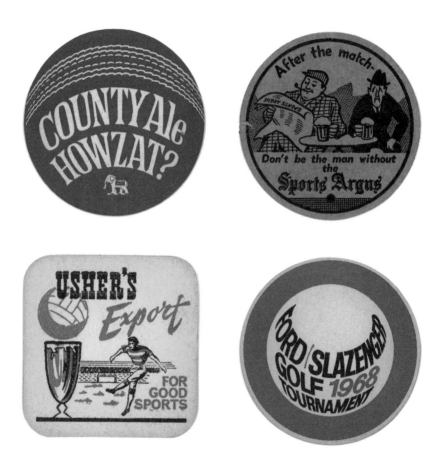

Fremlins County Ale 1966 • Sports Argus
Usher's Export 1963 • Ford Slazenger Golf Tournament 1968

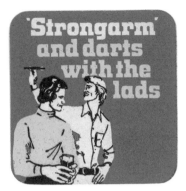

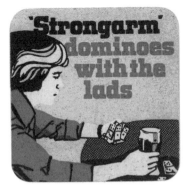

Cameron's Strongarm 1977

STOUTS

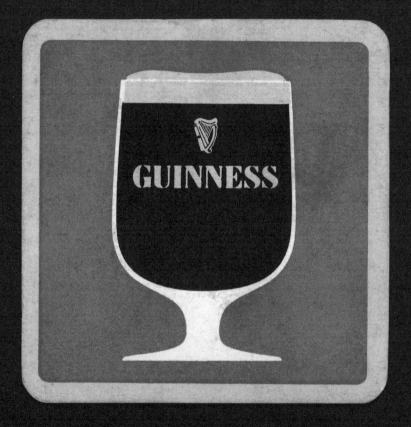

Guinness 1972

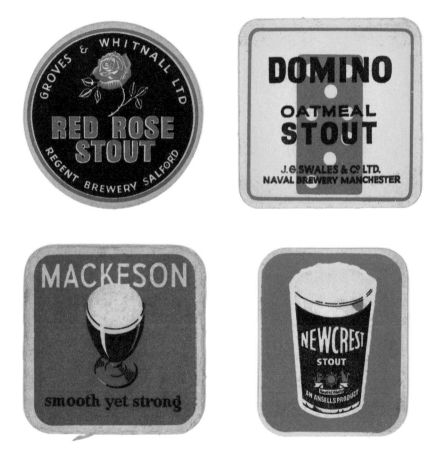

Groves & Whitnall Ltd Red Rose Stout 1963 • Domino Oatmeal Stout 1964
Mackeson 1958 • Ansells Newcrest Stout 1962

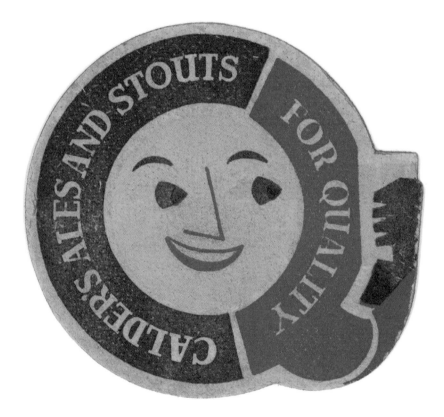

Calder's Ales and Stouts 1956

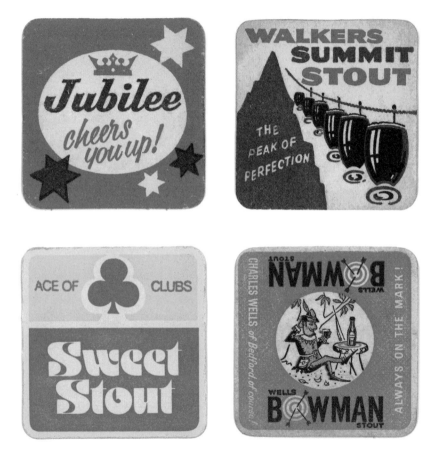

Jubilee 1964 • Walkers Summit Stout 1961
Ace of Clubs Sweet Stout 1977 • Charles Wells Bowman Stout 1962

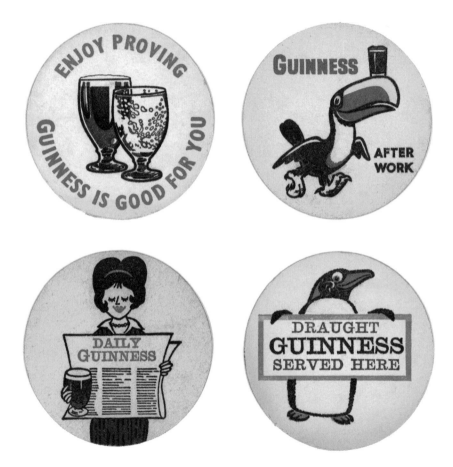

Guinness Enjoy Proving 1964 • Guinness After Work 1963
Daily Guinness 1963 • Draught Guinness Served Here 1961

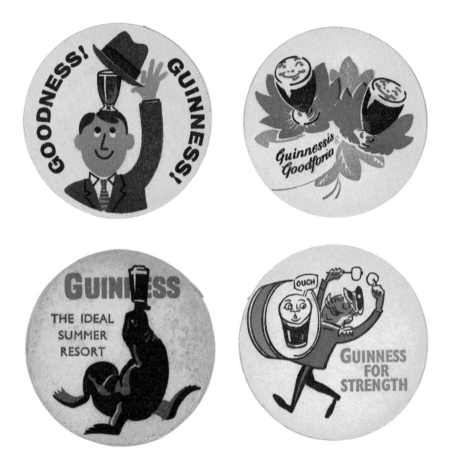

Goodness Guinness 1962 • Guinness Goodforia 1963
Guinness Ideal Summer Resort 1961 • Guinness For Strength 1964

WOODBINE
Britain's biggest
selling cigarette

Woodbine Cigarettes

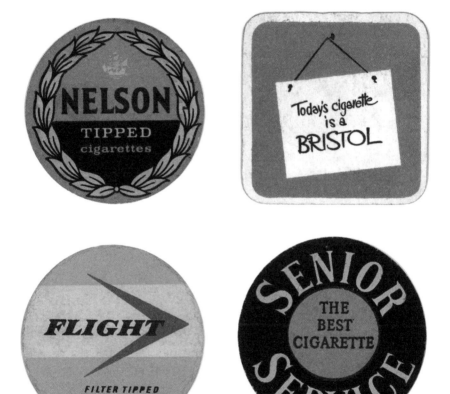

Nelson Tipped Cigarettes • Bristol Cigarettes
Flight Cigarettes Filter Tipped • Senior Service Cigarettes

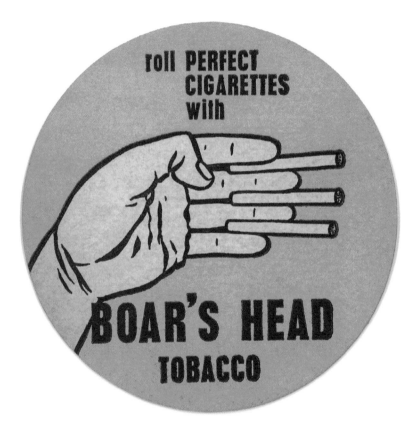

Boar's Head Tobacco

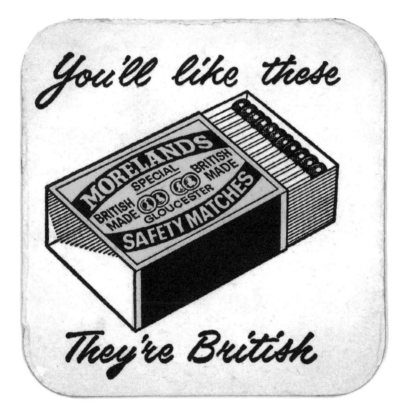

Morelands Safety Matches

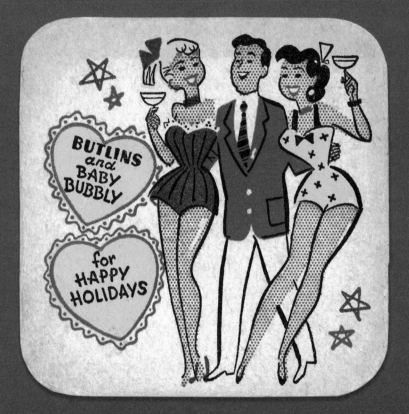

Butlins and Baby Bubbly 1962

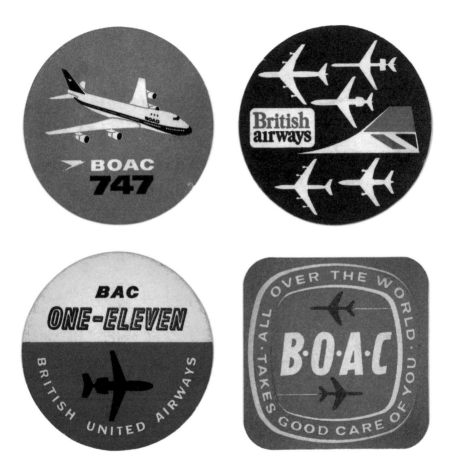

BOAC 747 • British Airways
British United Airways • British Overseas Airways Corporation

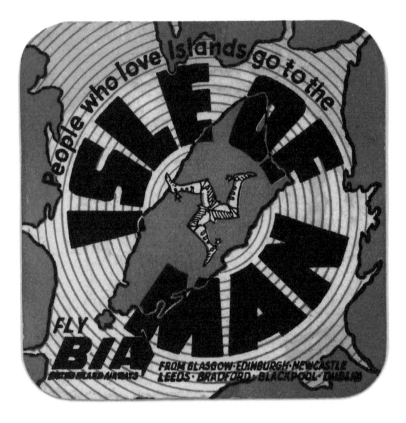

Fly BIA Isle of Man

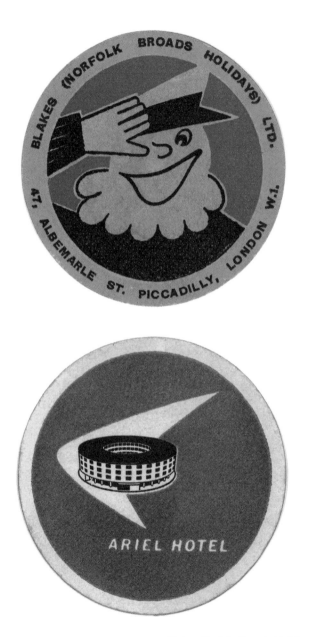

Blakes Norfolk Broads Holidays • Ariel Hotel

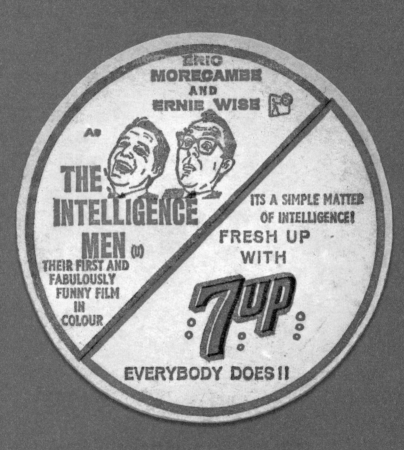

Morecambe and Wise *The Intelligence Men* and 7UP 1965

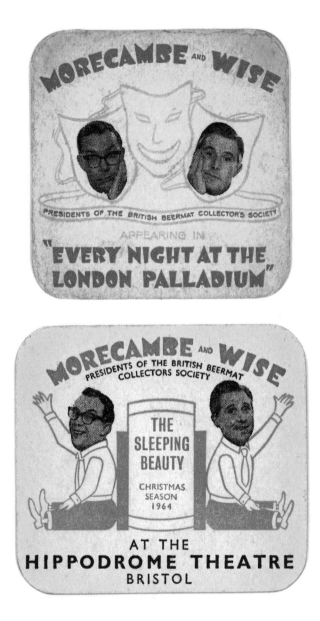

Morecambe and Wise *Every Night at the London Palladium* 1962
Morecambe and Wise *The Sleeping Beauty* 1964

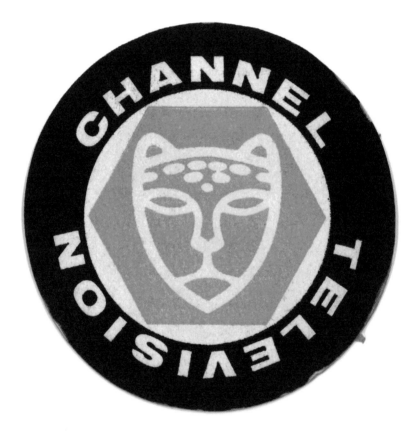

Channel Television

The Woolpack *Emmerdale* • Newton and Ridley *Coronation Street*

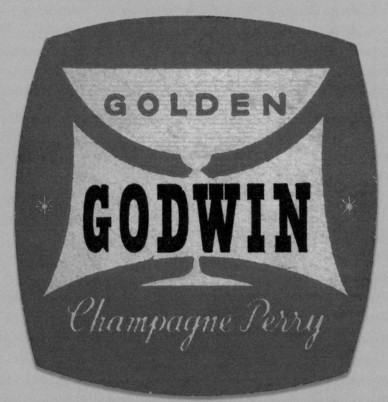

Golden Godwin Champagne Perry

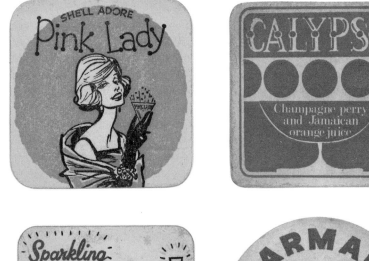

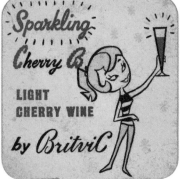

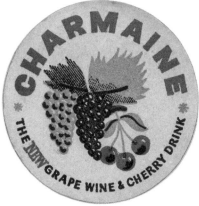

Pink Lady Perry 1966 • Calypso
Britvic Cherry B • Charmaine

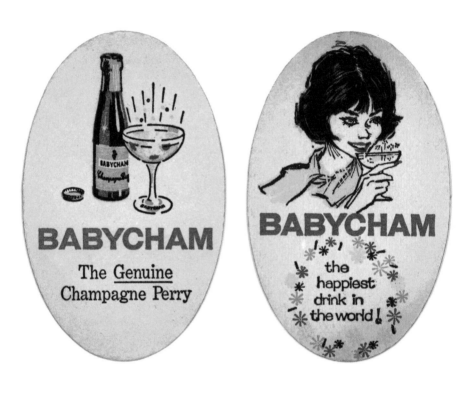

Babycham 1963

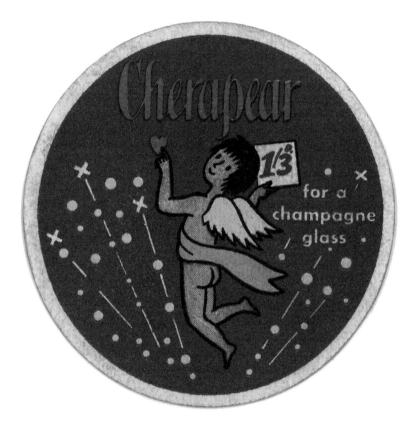

Cherapear Perry 1958

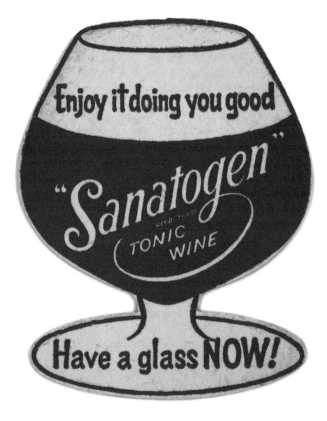

Sanatogen Tonic Wine

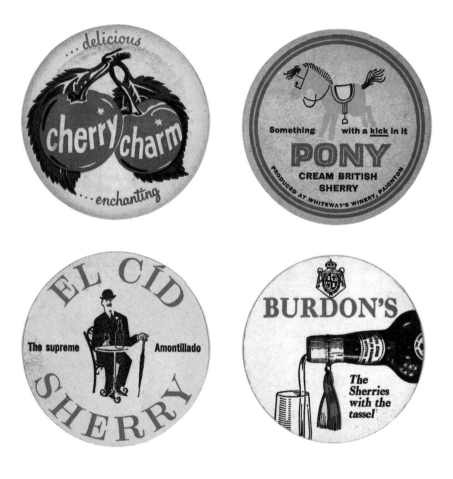

Cherry Charm • Whiteway's Pony Sherry
El Cíd Sherry • Burdon's Sherry

AND SOMETHING FOR THE HANGOVER

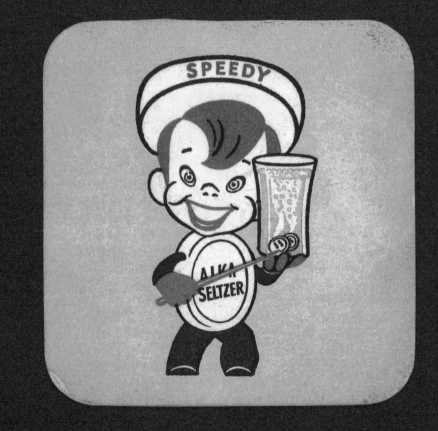

Alka Seltzer